JUST ADD COLOR

BOTANICALS

30 ORIGINAL ILLUSTRATIONS
TO COLOR, CUSTOMIZE, AND HANG

ARTWORK BY LISA CONGDON

Rockport Publishers
100 Cummings Center, Suite 406L
Beverly, MA 01915

rockpub.com • rockpaperink.com

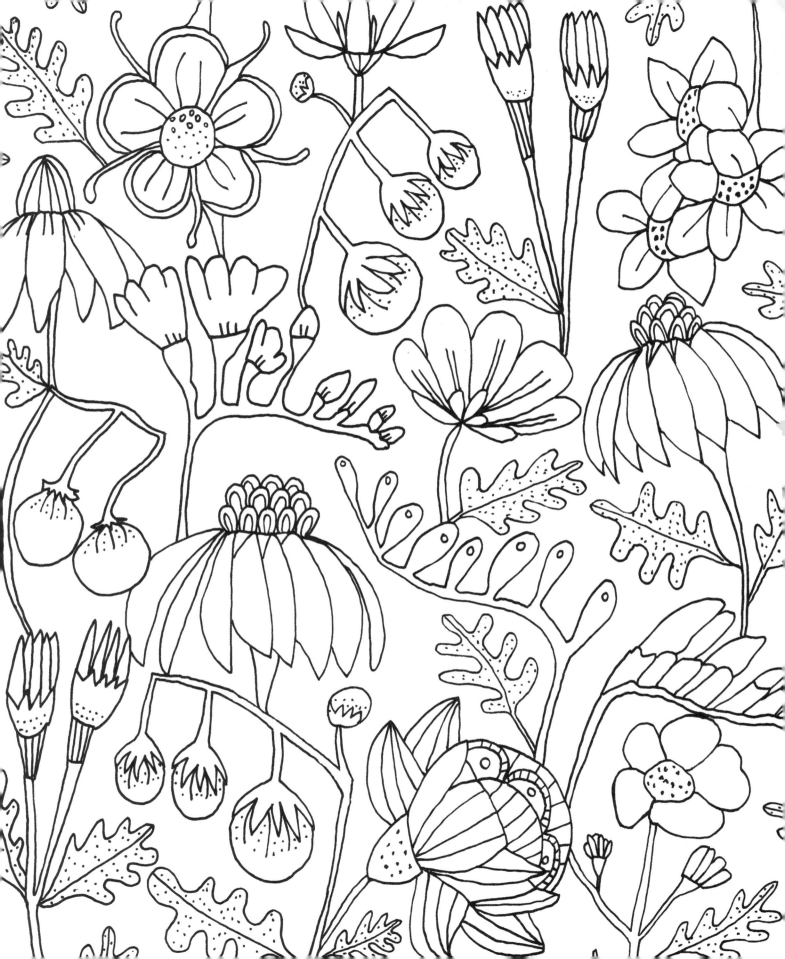

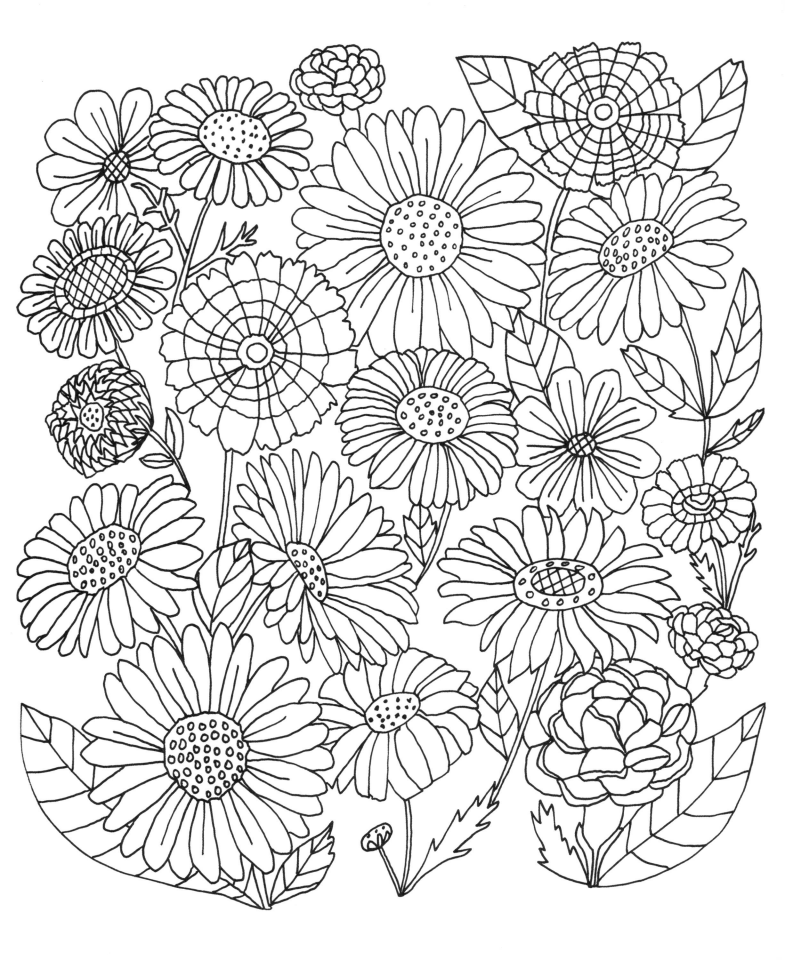

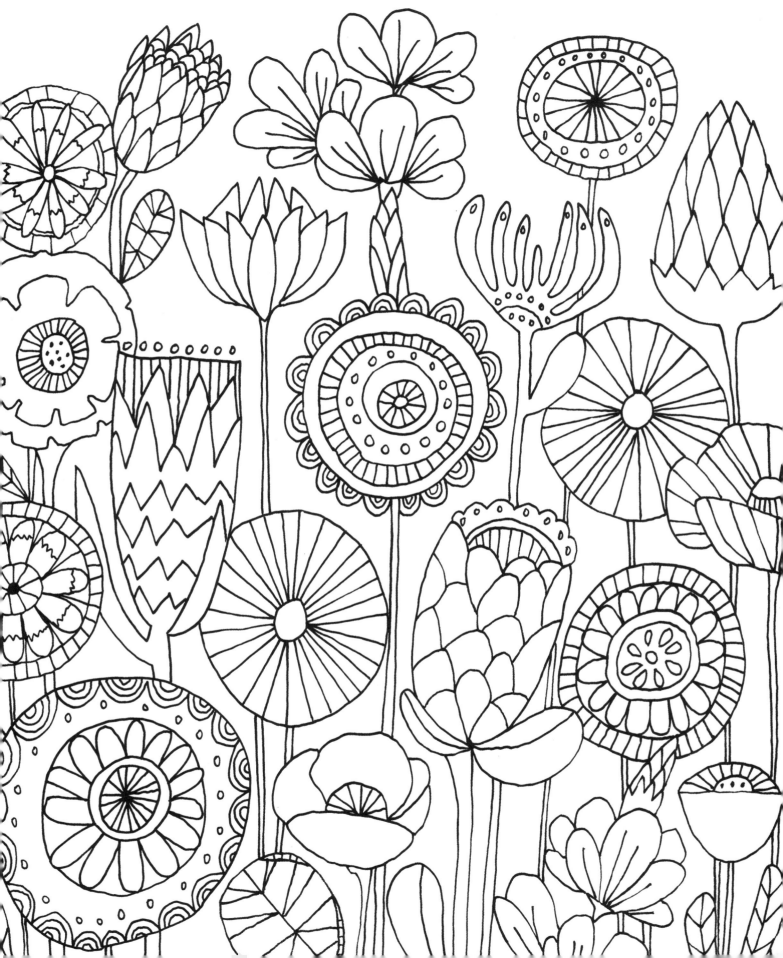

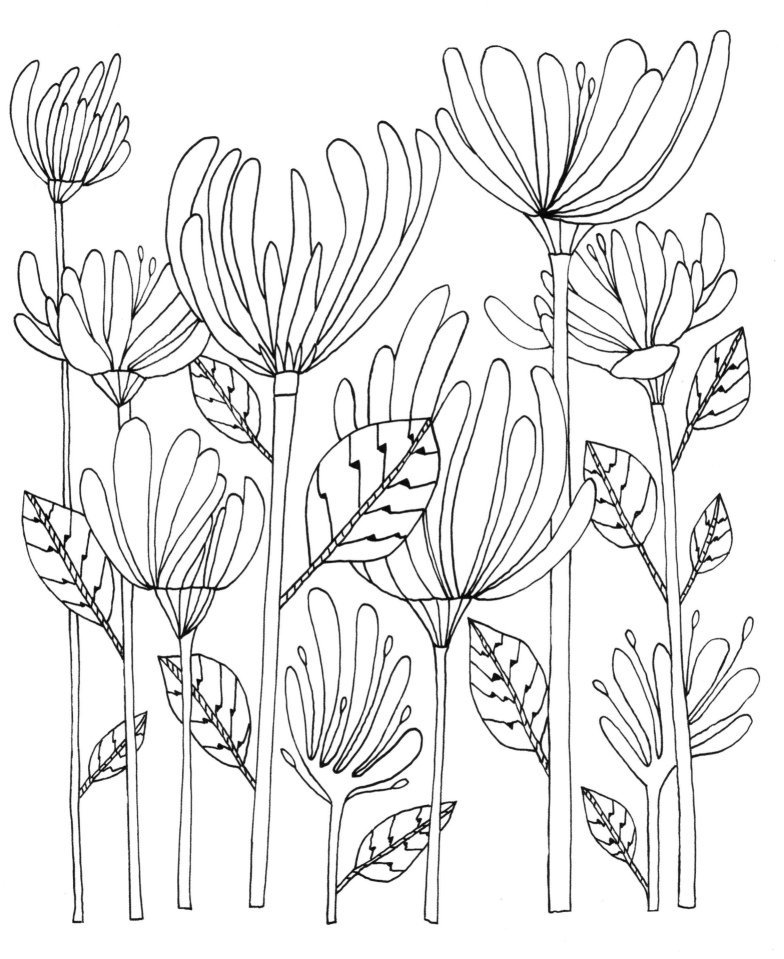

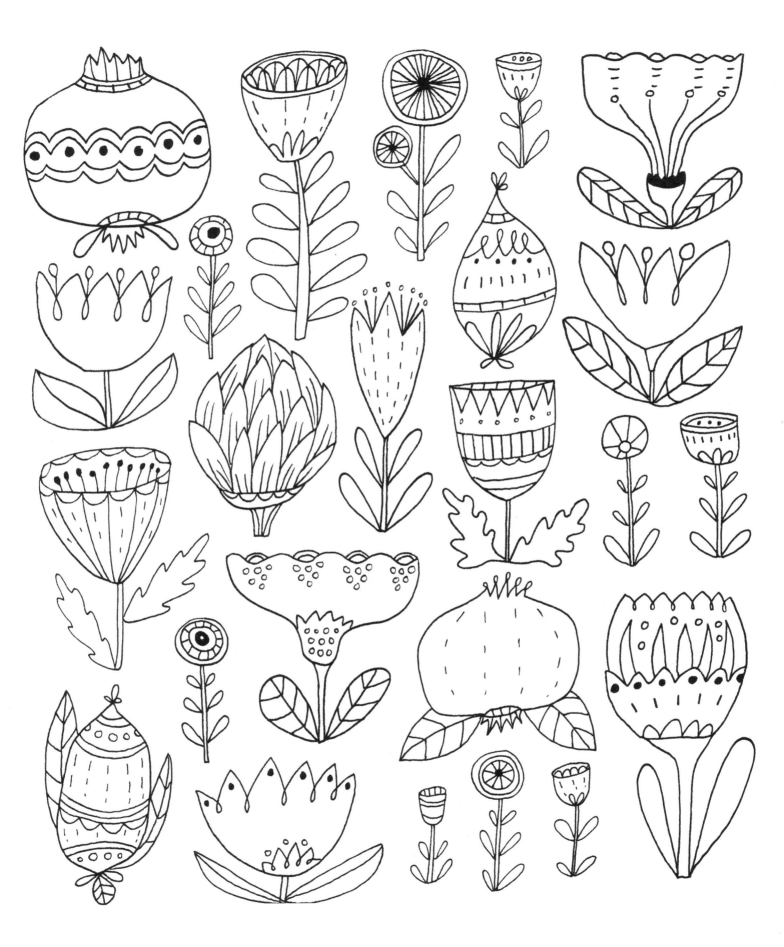

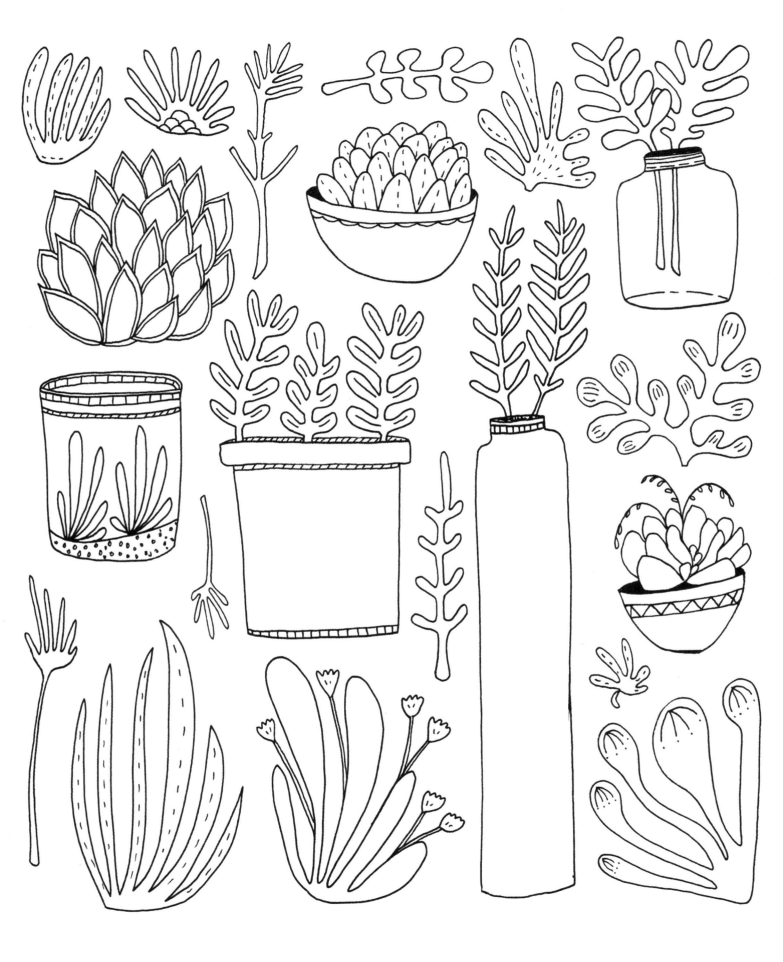

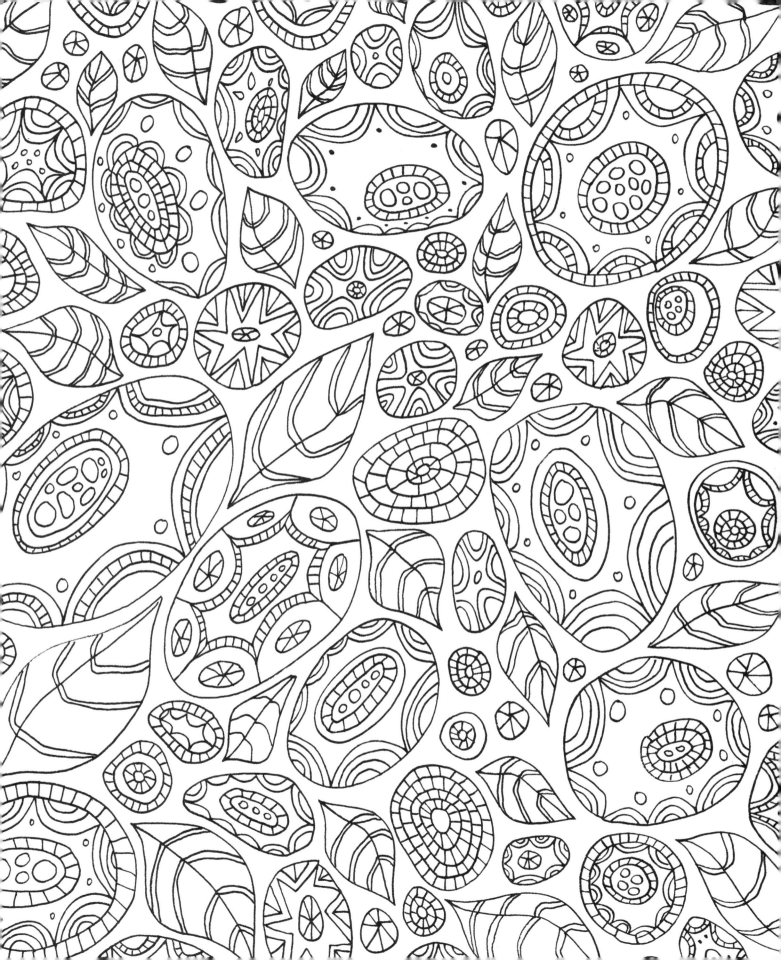

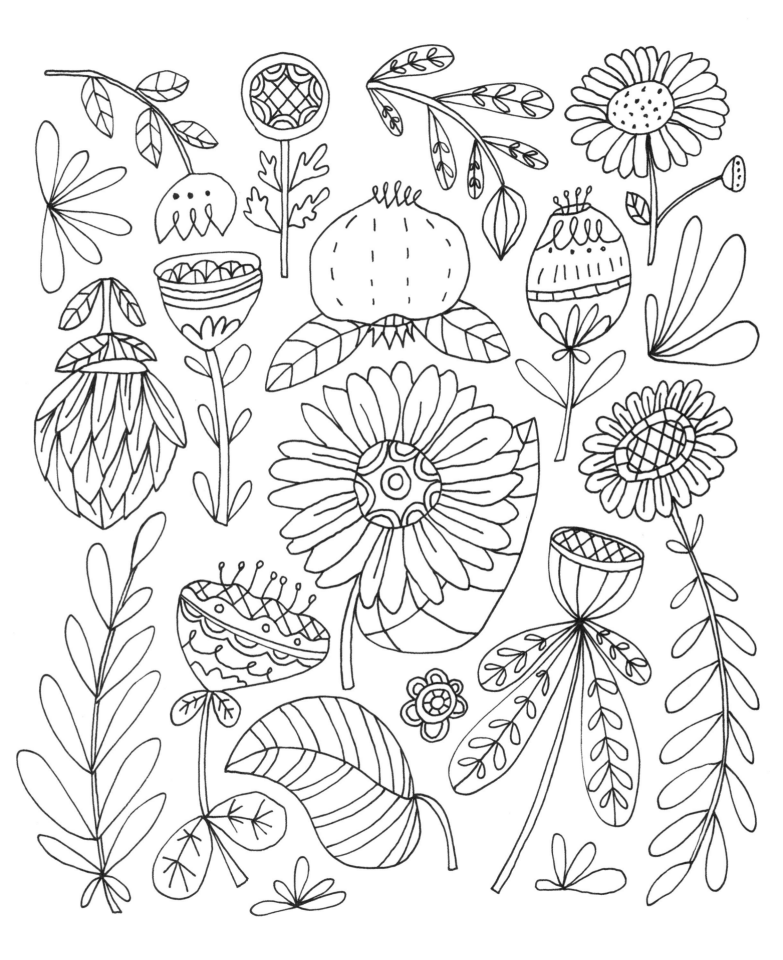

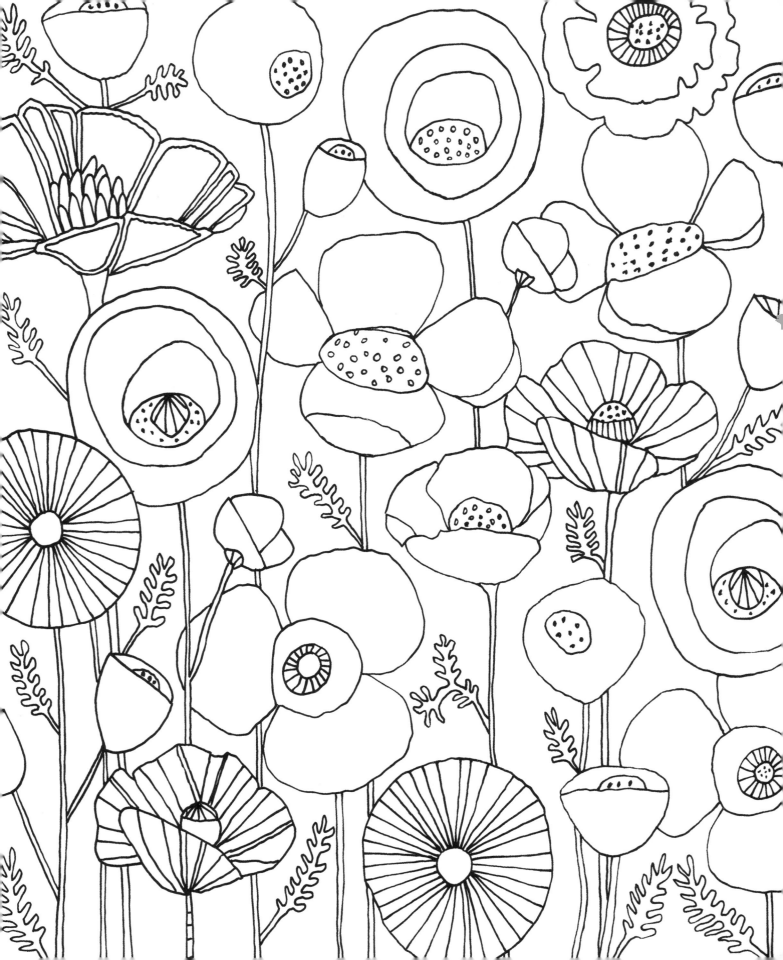

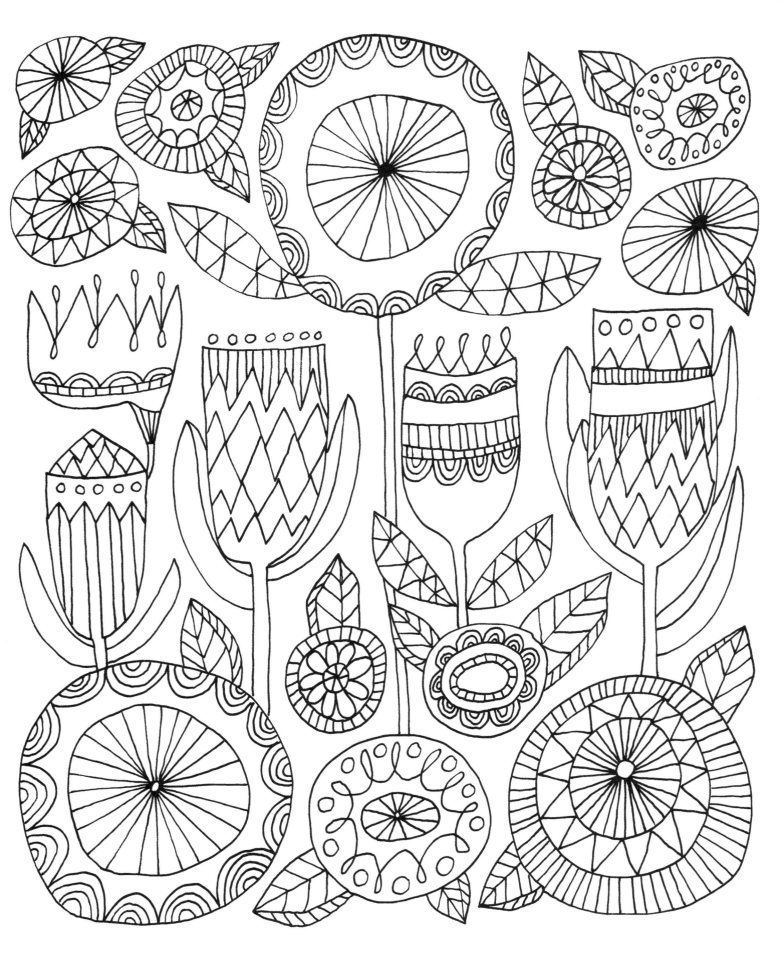

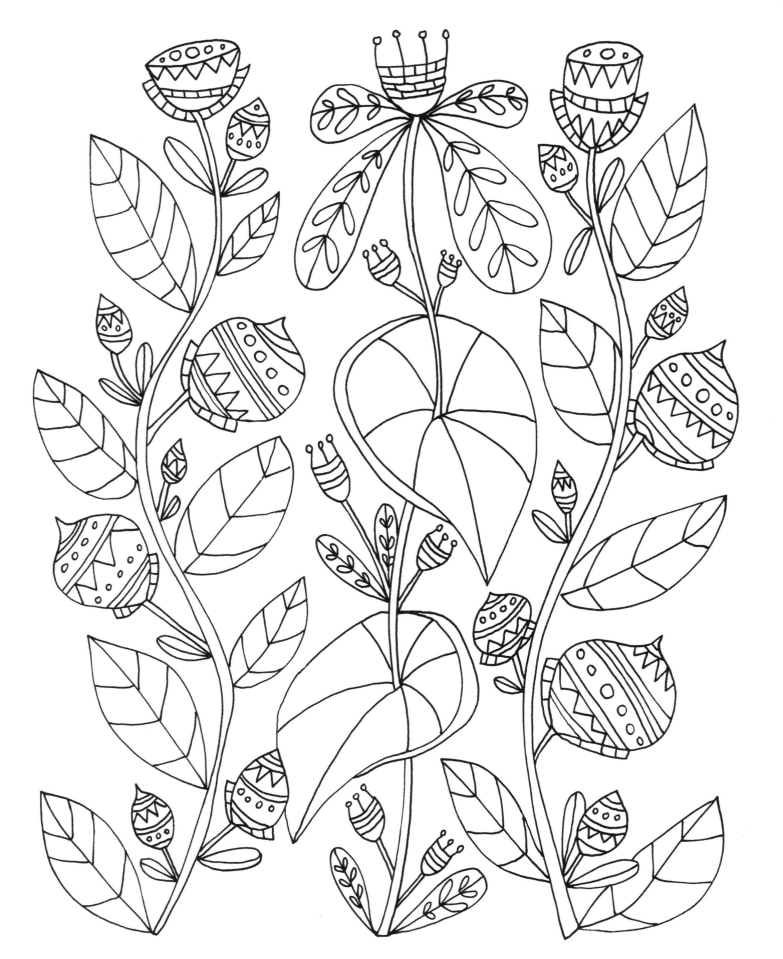

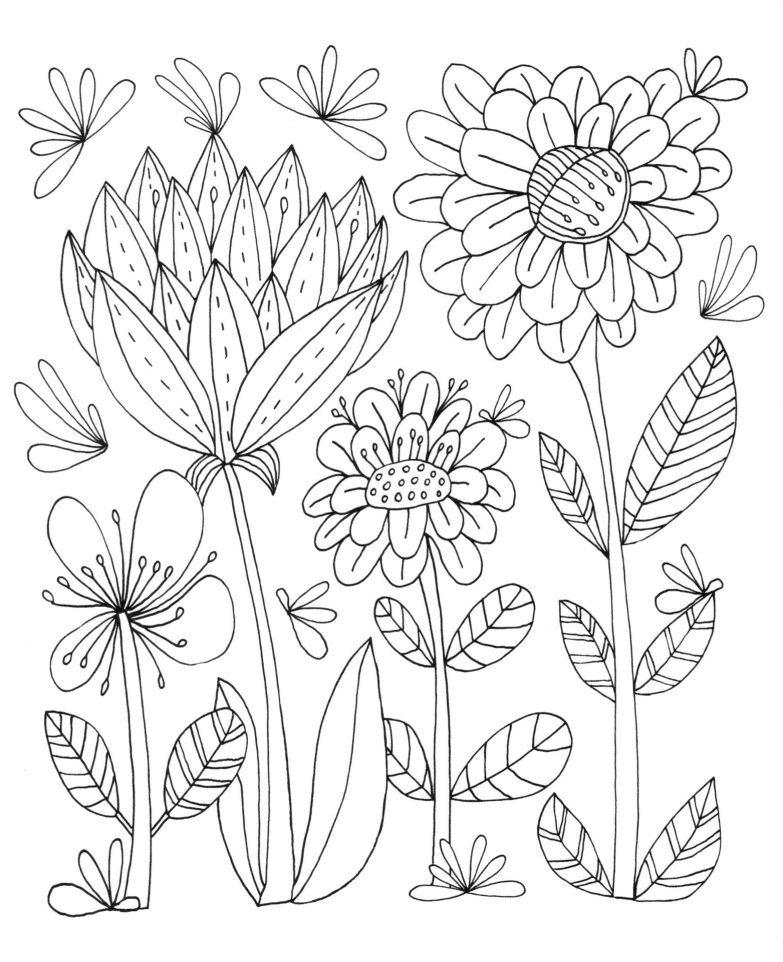

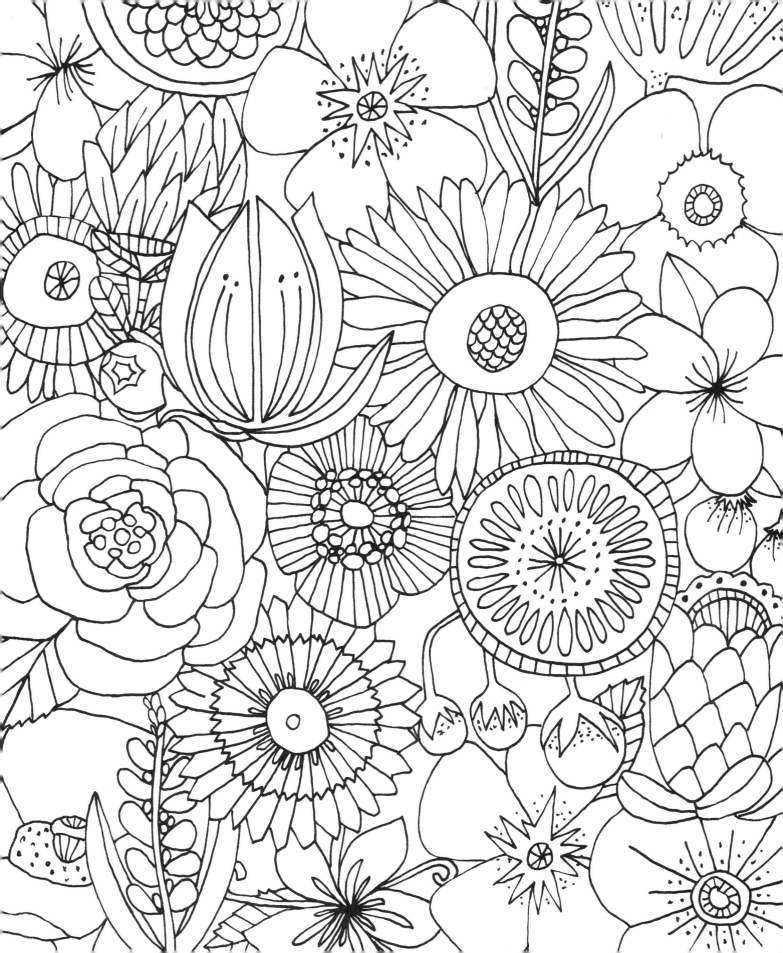

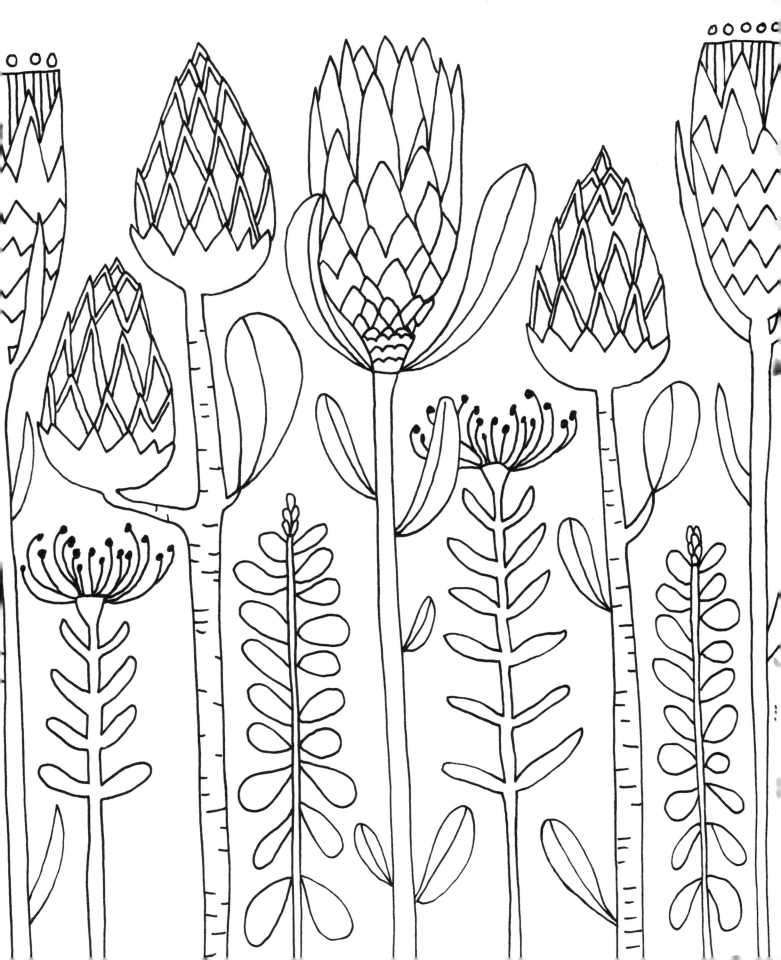

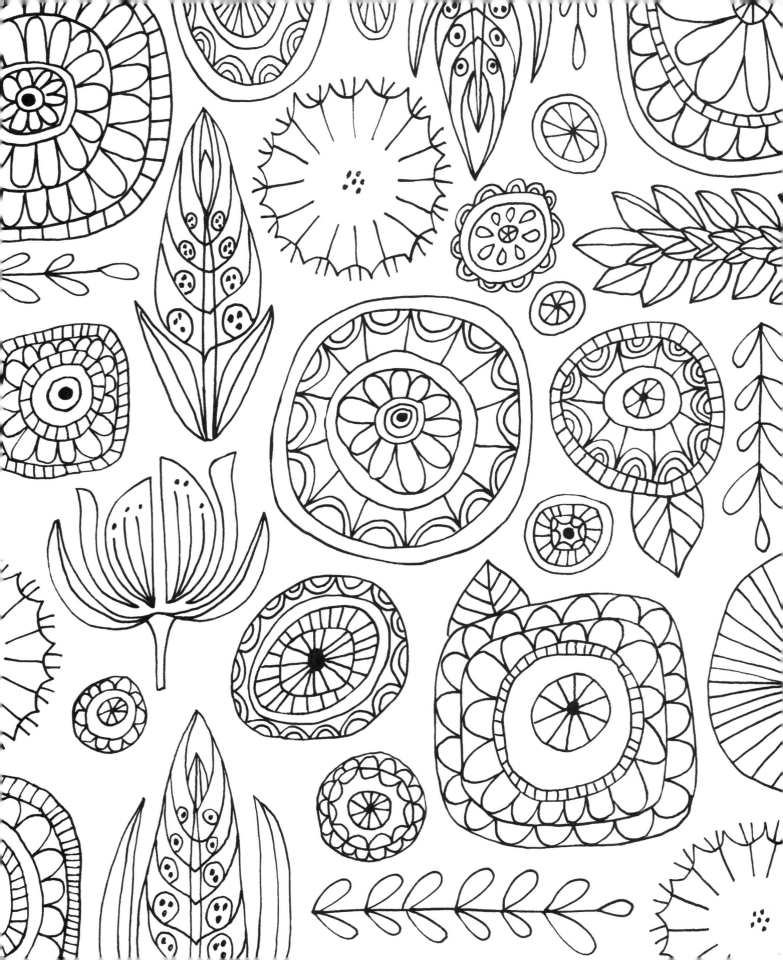

Artist and illustrator Lisa Congdon is best known for her colorful paintings and collages. Since 2007, she has been illustrating for clients including The Museum of Modern Art, *Martha Stewart Living* magazine, Rockport Publishers, Chronicle Books, The Land of Nod, and Simon & Schuster, among others. Lisa is also known for her intricate line drawings and pattern design, and has licensed her work for fabric, kitchen linens, wallpaper, and bedding. In addition to illustrating full time, Lisa maintains a thriving Etsy shop and writes a popular daily blog of her work, life, and inspiration called *Today is going to be awesome.* She is the author of *20 Ways to Draw a Tulip and 44 Other Fabulous Flowers* (Quarry Books, 2013) along with *Whatever You Are, Be a Good One* and *Art, Inc.* (Chronicle Books, 2014). Lisa is an avid cyclist and swimmer. She lives and works in Oakland, California.

www.lisacongdon.com

© 2014 Rockport Publishers
All images © 2014 Lisa Congdon

First published in the United States of America
in 2014 by
Rockport Publishers, a member of
Quarto Publishing Group USA Inc.
100 Cummings Center
Suite 406-L
Beverly, Massachusetts 01915-6101
Telephone: (978) 282-9590
Fax: (978) 283-2742
www.rockpub.com
Visit RockPaperInk.com to share your opinions,
creations, and passion for design.

10 9 8 7 6 5 4 3 2 1

ISBN: 978-1-63159-029-0

Cover and Interior Design: Debbie Berne
Cover Image: Lisa Congdon

Printed in China